RICHARD MEIER
COLLAGES

RICHARD MEIER
COLLAGES

ACADEMY EDITIONS
ST. MARTIN'S PRESS

Published in Great Britain 1990 by
ACADEMY EDITIONS
An imprint of
The Academy Group Ltd,
7 Holland Street, London W8 4NA

ISBN 1-85490-048-X

Published in the USA by
ST. MARTIN'S PRESS,
175, Fifth Avenue, New York, 10010

ISBN 0-312-05672-9

Printed and bound in Singapore

Publisher's note

We are grateful to Richard Meier for
his help in compiling this book which
is timed to coincide with an exhibi-
tion of his collages at the October
Gallery, London. We wish to thank
Lois E. Nesbitt for contributing the
foreword and Clare Farrow for
interviewing Richard Meier on behalf
of *Art & Design* magazine. This
interview was first published in A&D
3/4 90, special issue *Art and the
Tectonic.*

CONTENTS

Architecture is a discipline, a field of rules and restraints, reasons and rationales. And Richard Meier is very much an architect, having spent the last 30 years perfecting a design system for projects of increasing scale and increasingly elaborate configurations, from the very private homes to major public and private institutions.

But a tension exists in architecture between order imposed from on high and the givens of each individual site, programme, client and budget. Despite the apparent abstraction of Meier's designs (he describes the Douglas House as 'a machine-crafted object that has landed in a natural world'), he has always exploited the contingencies of each situation and used them to breathe life and instil individual character into each design.

Collage too arises out of what life throws in our paths: Kurt Schwitters scavenged for materials on city streets; the Cubists found theirs on the table tops of favourite cafes. The very idea is a technique based on found materials challenged the sterility and artificiality of the neat arrays in art supply stores, favouring a more direct link between what we live with and what goes into our art. Richard Meier gathers his scraps of paper while travelling (some compositions are even executed in notebooks during intercontinental flights),

out of the daily mail, from newspapers and magazines.

Paradoxically, however, while Meier works on the compositions during the spare moments permitted on business trips or late at night, after the office duties are over, this escape from the rigours of the design process ends by returning to that process. In his youth Meier divided his time between painting and architecture, unwilling to sacrifice one for the other. A student of post-war Abstract Expressionism, Meier at that time produced highly gestural canvasses. Traces remain in the collages: angry scrawls of red or black litho crayon obliterate printed texts, adding a fevered energy to the compositions. True to his New York School origins, Meier also deletes any explicit thematic strands from the collages, favouring instead juxtapositions of pure colour. The architect's strong colour sense (conspicuously absent in his pristine white buildings) for gradations of pastels of the high-contrast Constructivist palette of red, black, grey and white derives from a painter's sensibility. But years of a now ingrained architectural method inflect these sketches in paper. A recurrent configuration – the floating diagonal rectangle almost filling the frame – recalls Meier's many plans based on 'grid shifts' in relation to the edges of the site. The free-form curves of

FOREWORD
by Lois E. Nesbitt

torn paper contrasting rectilinear elements suggest the Corbusian bulges of certain Meier buildings; when layered in loose parallels they also suggest the contour lines of site plans. Sudden, partial appearances of lettering or photographic images resemble the 'incidents', or non-narrative 'episodes' punctuating passage through Meier's interiors. Overlays of parallel grids or orthogonal elements echo his characteristic sectional layering and elaborate fenestration patterns. Architectural too – and particularly associated with certain designers of Meier's generation – is the standardisation of format (most works are ten-inch squares with solid-colour backgrounds reminiscent of origami paper), the setting up of fixed parameters within which to experiment.

An architect's sensibility, then, shapes these works, but so does the architect's life. No single collage documents a particular trip, episode, or period of Meier's life; they in no way constitute a visual diary, and autobiographical elements are discreetly suppressed. Rather, Meier constantly collects materials, stores them, and later combines them without giving thought to their origins. Favourite scraps are used over and over – seen throughout the works presented in this exhibition, for example, are the fragments of Cyrillic typography collected on a lecture tour to the Soviet Union. What one gleans, looking at the works as a whole, is a picture of the contemporary architect's life: the ubiquitous ticket stubs and fragments of foreign languages tracking to a routing of international travel; the numerous exhibition announcements and stylish graphics testifying to hours spent perusing art and architecture books or strolling through museums and galleries. Far from Schwitter's mundane materials, Meier's stock is highly filtered, reflecting a cultured, European sensibility and willfully blinded to the less aesthetically appealing elements of modern visual culture (absent, for instance, are appliance-store advertisements, supermarket coupons and the like). Yet these compositions have an intensity, an urban energy lacking in the calm, literate collages of Meier's contemporary, artist Robert Motherwell. Indeed, though vastly different in scale, Meier's rich overlays of torn paper more closely resemble those of French *nouveau realiste* artists like Jacques de la Villeglé, who since the 50s has been making collages out of posters torn off the walls of Paris streets.

Meier's techniques and materials draw on the collage tradition; as such they are neither startling nor radical. But such criteria do not seem appropriate in evaluating much late 20th-century art. Meier's architectural projects, which continue the explorations of earlier Modernists like Le Corbusier, argue that the artistic innovations initiated at the beginning of this century continue to provide fertile ground for today's creators. As in his architecture, Meier in the collages patiently and relentlessly expands the possibilities of an inherited formal and material technique. His genius lies in the freshness with which he tackles each new exploration and the astonishing variety of the results.

Defined as a 'New Modernist' in the tradition of Le Corbusier's white architecture, Richard Meier here discusses his collages in the context of his architectural principles. Perceiving certain formal similarities in the dialogue established between the rectilinear and the curvilinear, explored in both his art and architecture, Meier explains the thinking behind his compositions.

— You have been quoted as saying that 'Abstraction is an important, vital part of every art movement existing today, music, painting, sculpture and certainly architecture'. Do you consider abstraction to be a means of breaking down the boundaries between the arts?

For me, everything in life has a certain degree of abstraction and in some way an appreciation of that fact allows one perhaps to see interrelationships between the various arts, and also perhaps to have a clear understanding of the intentions and ideas which exist in painting, music, or architecture.

— Would you draw any analogies between your architecture and other disciplines, such as painting, sculpture or music? I'm thinking in terms of the abstraction, the linear rhythms, the spatial intervals . . .

I love music that does that, whether it be Philip Glass, or Beethoven, in the sense that there is a linear element and there's also space. And although personally I don't like to make analogies between architecture and music — that's for the critic to do — I believe that they do exist. However, I do not believe that one derives one's own intention as an architect necessarily from that which goes on in other fields. I believe that architecture is derived from architecture, and not from interpretations of painting, sculpture, or music. I do think that there are ideas which are relevant to all fields of endeavour, and that somehow they're in the air, and in our heads, as it were, and one cannot ignore them; on the other hand, I would be very sceptical of a musician, for instance, who says that his music derives from an understanding of a particular architect's work.

— So do you see your architecture, conceived in terms of abstract line, space and light, as an autonomous, self-referential art form, transcending the functional demands of the discipline?

Yes, definitely. I think function for an architect is like structure; you take it for granted that it works, that it stands up and that it's built well. That's a given. It's what happens beyond that which makes a building meaningful as a work of architecture.

— In your adherence to the principle of abstraction, do you consider your architecture in terms of 'New Modern-

RICHARD MEIER
The Art of Abstraction

ism', as signifying a continuity with the principles of Le Corbusier's white architecture, and the designs of Mies van der Rohe?

I've always hated categories and have always wanted to resist them to whatever degree possible, certainly to resist categorising myself. You can't help it if other people put you into categories. I have to acknowledge certain debts, and certainly a great debt to Le Corbusier; his work was part of my learning about architecture. But I always find it difficult: I'm there, I may fit into a category, but one still wants to resist. When I was in architecture school, in the late 50s, of course Mies van der Rohe was one of one's heroes, as were Le Corbusier, Alvar Aalto, and Frank Lloyd Wright. So I frankly feel that each of these great masters has been influential in my work.

– An aspect of your treatment of space, rendered in geometrical terms, is your grid system, organised on the white surface as a visual system of identical squares. Can you comment on this?

Each building is somewhat different, but in the use of the metal panels, which I have been working with for many years, the gridding exists in plan and section. The use of the panels is simply an expression of an aspect of that grid, which not only comprises the cladding system, the division of window mullions and railings, and the interrelationship of all these linear elements, but also has to do with the structure and organisation of the spaces. So it's a three-dimensional construct. The grid in each building is somewhat different, depending on that particular building's needs, organisation and expression. Nevertheless, the gridding is always a scaling device which finally brings the scaling of the elements down to human proportions.

– Can we discuss your treatment of colour and light? You seem to concentrate on the experience of white and transparent surfaces, of space, and the play of light and shadow; what are your reasons for reducing the colour of your architecture to pure white?

For me it's really the clearest expression of all the architectural ideas which are manifest within the building. The whiteness allows one to perceive, perhaps more clearly, planar elements juxtaposed against linear elements, for instance. It allows one to perceive the differences between transparent, translucent and opaque surfaces; it clarifies the intention in terms of the way in which light comes, in various ways, into the building; and I think for me colour is something which comes from all the things which are out of control, the changes of nature, the uses of the building, the people in the building . . . Everything gives it

colour. You don't need to paint or colour the surfaces because there is so much colour that is a part of the architecture, and the whiteness is really that which is static and un-changing to some degree. The colour is constantly changing.

– *Do you see the architecture then as establishing a dialogue with the changing colours both inside and outside?*

Yes I do, and in a sense the architecture is always changing itself, because of the way it reflects colour and refracts colour, the way that the shadows change, and the seasons change.

– *A dialogue is also established in your architecture between the straight line and the curve. Can you comment on this?*

I've always tried – maybe it's a kind of baroque aspect of my nature – to create an order and then to give a counterpoint to the rectilinear order that is established. That's really what the curvilinear elements do. In a sense they're an expression of a hierarchy within the construct. Generally I would like to think that that which is curvilinear is not only more fluid spatially, but more fluid in terms of saying something about the nature of that particular space within the building; that where there is this juxtaposition of curved forms against linear forms, that which is curved has a more important position in the hierarchy of the building.

– *Charles Jencks has described your space and abstraction as 'magical, disorientating, all encompassing', signifying 'an in between moment of time when normal categories of time are suspended'. Does the notion of time play a part in your thinking processes?*

For me, the most positive criticism of my work would be to say that it's timeless, because I would like to think that architecture is not only related to the past and to the present, but that it also has a life of some indeterminate length in the future. Architecture is not a concep-tion of the moment. Architecture is very much a part of culture. While architecture may be timeless in one sense of the word, it is inextricably connected to the period from which it has emerged.

– *You have been quoted as saying that 'I make architecture primarily in what I consider to be the mind of man.' Do you consider your architec-ture to be primarily a 'cerebral' art form?*

Oftentimes, when I have given a lecture and there have been ques-tions at the end, someone will say 'why don't you show people in your photographs?', as though that gives it some meaning. I don't think it does. I think that the meaning comes from the work and from the perception of the work, not from what it feels like to touch or what it looks like

when activity is occurring. It is what it is, and the need to load it with other meanings is unimportant to me.

– How important is the treatment of light and space in your museum designs? Do you concentrate on natural or controlled conditions of light?
The museum is a changing experience in terms of the way in which one views a work of art. It's not only a one-to-one relationship, of the viewer to the object, but it's also a relationship that the architect must establish between the viewer and the environment, or the space; in other words, to that which is around you, not only that which is three or four metres away. The spatial experience should allow for the contemplation of works of art from close up, and from a distance, but also there has to be a periodic interval allowing the viewer to see nature, to see natural light, and to have a kind of syncopated rhythm of experiences as one moves through the museum. Otherwise museum fatigue takes over and it becomes quite a boring spatial experience. Architecture can enhance the museum experience, it can magnify it, it can add something important to it, and this has to do with natural light as well as its control because, natural light is the enemy of art. Therefore daylight has to be controlled at certain times of the day.

– What criteria determine your treatment of space in a museum?
Each museum is different and each collection is different, for instance, in terms of scale. The collection at the Museum Für Kunsthandwerk in Frankfurt, for example, ranges from very small objects such as glasses and tableware, to chests and room environments. So I think the architecture has to stand on its own as a work of art. Certainly it must be sympathetic to the collection of the museum, in terms of its organisation and the kinds of spaces that one's creating. There should be a variation of scale, a hierarchy of large and small spaces, through which the collection can be seen in different ways.

– In discussing your design for The High Museum in Atlanta, you have cited the Guggenheim in New York as an inspiration. In what ways did Frank Lloyd Wright influence your thinking?
I had the very good fortune, many years ago, of being asked to make a small renovation in the Guggenheim, where I converted a broom closet into a members' reading room. And when I was working on the design of this renovation within the Guggenheim museum, I realised that one of the marvels of the building is that you see a work of art close up and then you move away and see it again from a distance; you see it from one level and then another

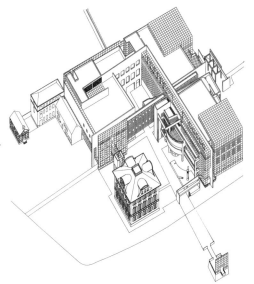

Museum of Decorative Arts, Frankfurt

level, and you can go back to it, if you so choose. I think that, for me, the most important aspect of the museum is that you don't leave a picture by leaving the room. At the time I thought that that was an important thing to remember in the design of a museum; and I also wanted to bear in mind the significance of that wonderful central space that is filled with light. What I tried to do in The High Museum in Atlanta was to straighten out the Guggenheim, so that all its problems, in terms of its sloping walls, ceilings and floors, which makes the viewing of art somewhat difficult, could be handled in a totally different way. And I felt that the Guggenheim's central space, the top-lit wonderful space, that acts as the orienting space within the building, could be expressed in a different way, but nevertheless as an organising space at The High Museum.

– Your design for the J. Paul Getty Center in Los Angeles (to be completed in 1997) comprises a complex of cubic masses, interwoven with other gallery spaces, creating a collage of autonomous forms. Kenneth Frampton has described it as 'Meier at his most "baroque"'. Can you comment on the thinking behind your design?

The Getty is, as you described it, a series of interconnected buildings, so that each collection is, in a sense, in a small building. It's one building but it's also many buildings. Each one is somewhat different: for instance, the 16th-century gallery is different from the decorative arts gallery. When you get to the 19th-century collection, those spaces again are different. This museum complex, one of seven buildings on the site of the Getty Center, also happens to the largest building in the public part of the Getty Center. But it's not the only building; it's part of a larger whole. The buildings, one could say, are in some ways fragmented like my collages, and yet I would like to think there is a unified whole, not only for the museum, but for the entire Center.

– Kenneth Frampton has also highlighted the importance of using different materials to differentiate planes and to achieve a legibility of autonomous forms. Do you apply the same principles to your collages in which, again, you seem to be exploring the interaction between spatial planes and materials, creating an overlapping and fragmentation?

Yes, I do. Always, within the collages, there is fragmentation and there is organisation. For the most part there is a rectilinear organisation, which is then related perhaps to curvilinear elements, and there's a sense of structure. The structure in the collages is generally based on the material at hand, so although the structure of the buildings is based on

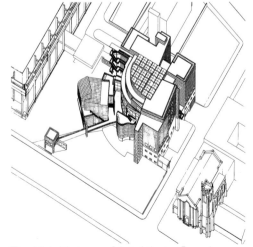

The High Museum of Art, Atlanta, Georgia

perhaps a more clearly defined grid, which is the structural grid, and then within that there can be fragmentation and a shifting of grids, there are certain formal similarities.

— *The materials in your collages seem to incorporate a 'chance' element.* What intrigues me about the collages — and the reason that I do them — is that they are totally by chance. I do the collages for myself, not for anyone else, so it's rare that I display or frame them. Most of the collages I have done are in books. To some degree they're made from things that I've picked up in my travels and put in my pocket. They also include photographs of my children, or papers which are thrown on a shelf, with the thought that at some time they might be useful in a collage. I carry a box with me on the aeroplane — I do collages on trips to various places — and for the most part most of the collages are done in a book and then put on a shelf as a kind of private diary.

— *So the materials do have a certain significance?*

One of the problems is to get rid of the significance, in a sense to destroy the significance, in order to make a construct in which the individual materials used are a part of a larger thing.

— *The collages also include scribbles crayoned over layered writings and materials, outlining planes and spatial forms, and rendering them abstract: what was the thinking behind this?*

The collages are layered, planar and spatial. They are what they are, personal visual images which derive their being from the material at hand and the act of transformation.

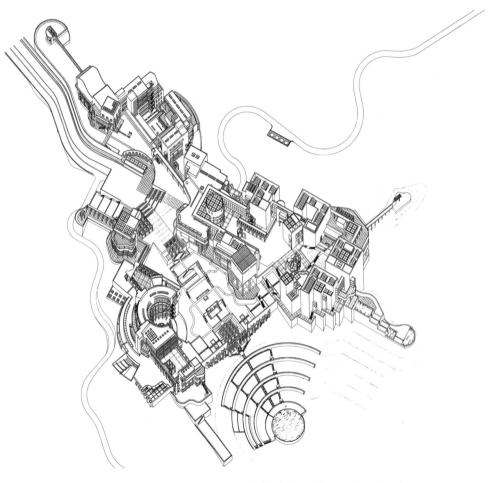

J. Paul Getty Center, Los Angeles

THE COLLAGES

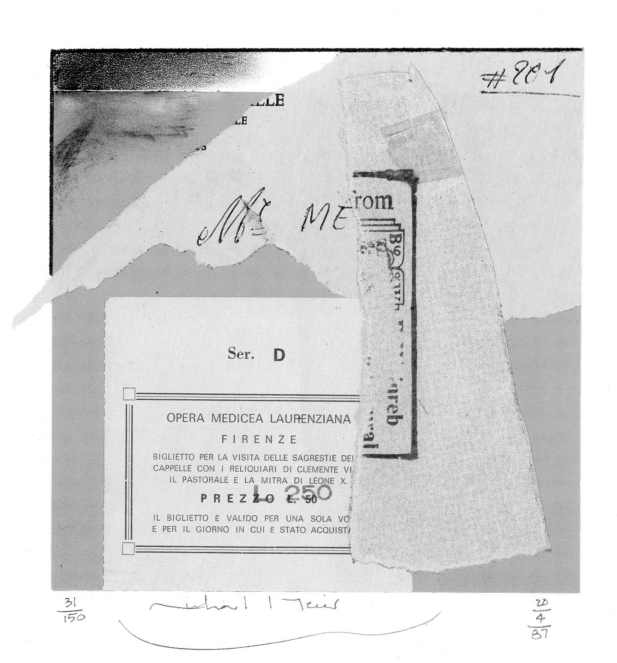

#801

Ser. D

OPERA MEDICEA LAURENZIANA
FIRENZE

BIGLIETTO PER LA VISITA DELLE SAGRESTIE DE
CAPPELLE CON I RELIQUIARI DI CLEMENTE VI
IL PASTORALE E LA MITRA DI LEONE X.

PREZZO L. 50 L. 250

IL BIGLIETTO È VALIDO PER UNA SOLA VO
E PER IL GIORNO IN CUI È STATO ACQUISTA

31/150 20/4/87

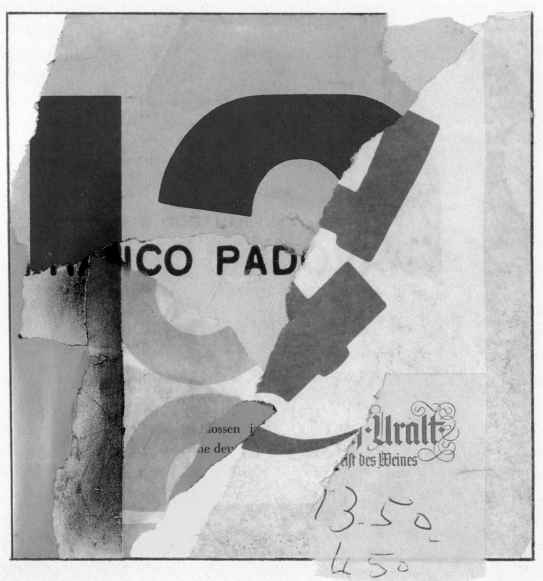

NCO PAD

Uralt
eist des Weines

13.50
4.50

michael l. Meier

28
5
87

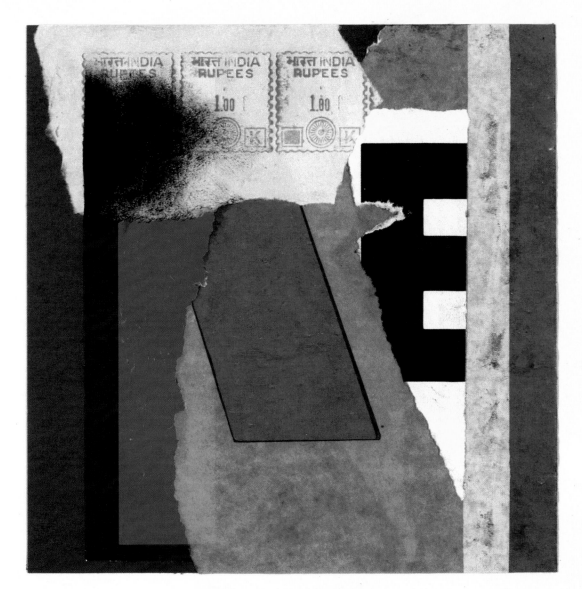

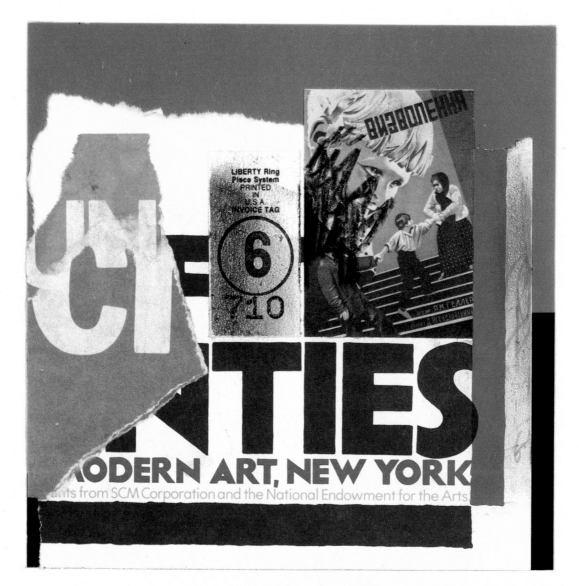

Richard Meier

28
—
5
—
87

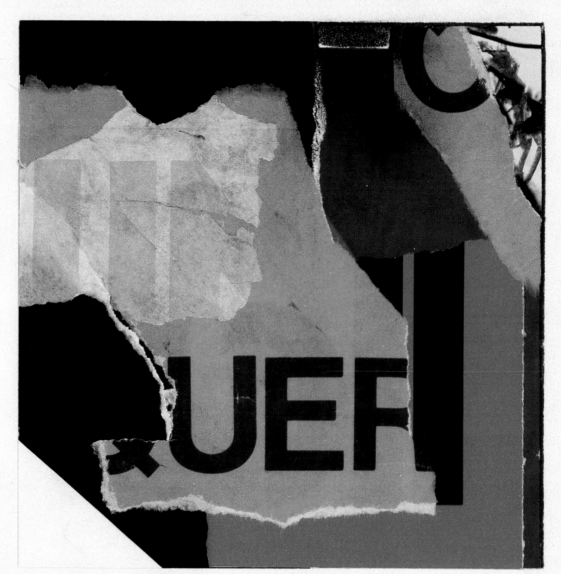

Michel Tèues 28
 5
 87

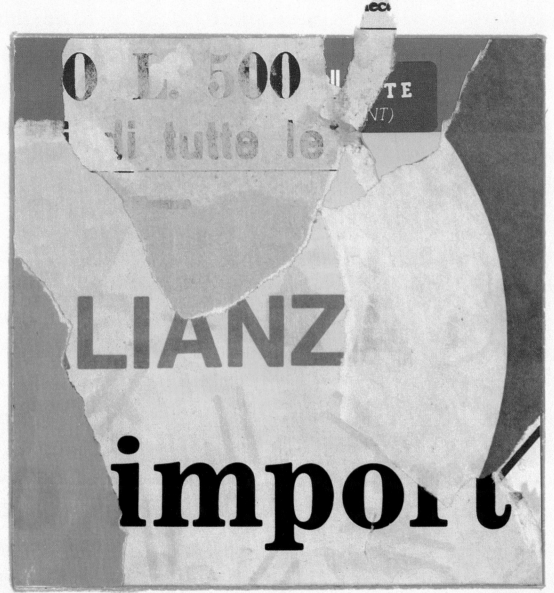

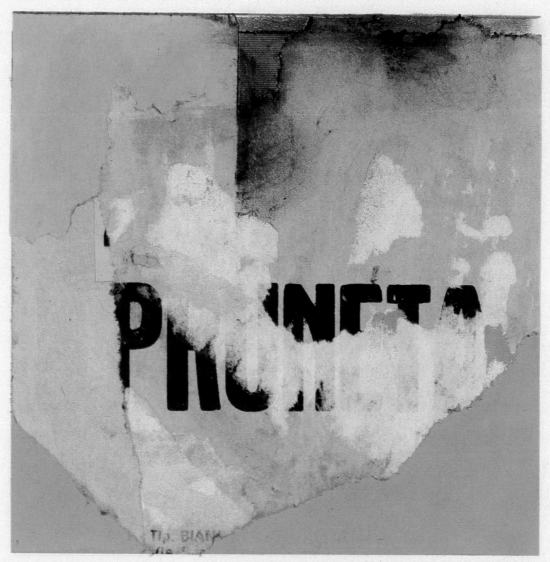

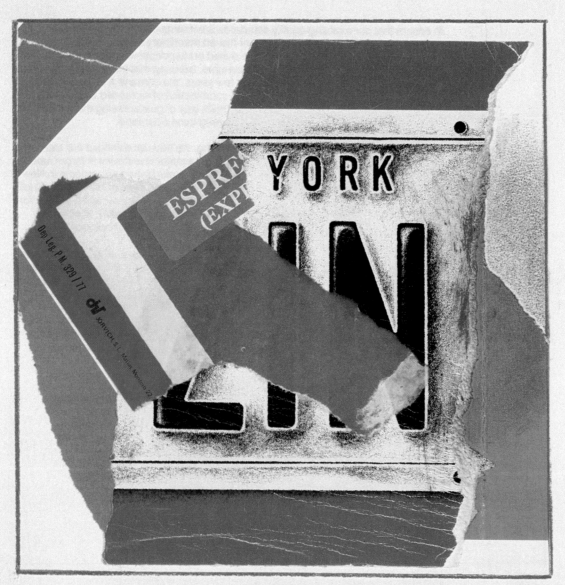

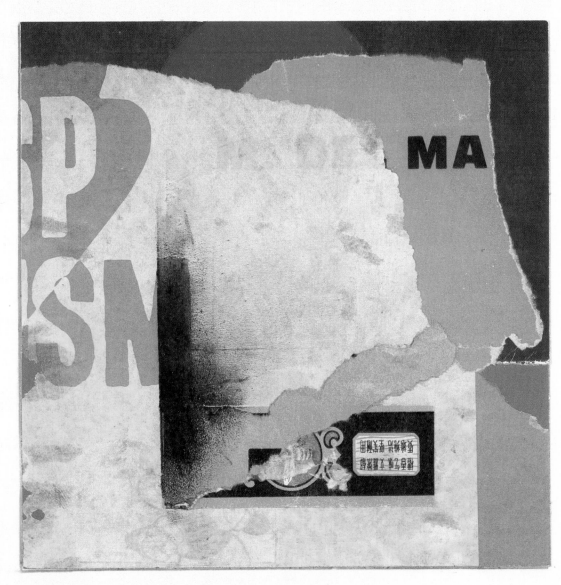

michael l meier 28/5/87

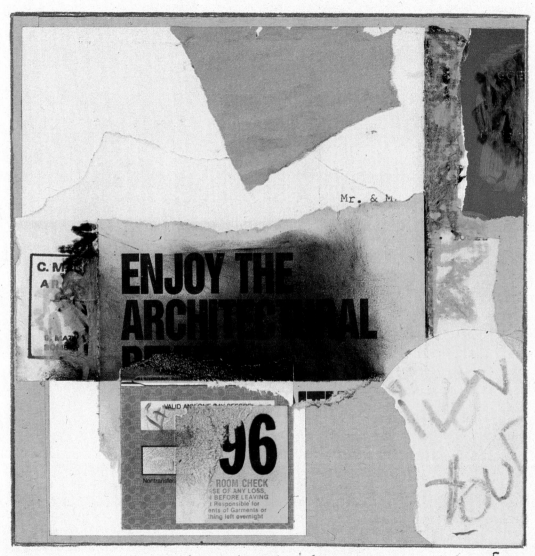

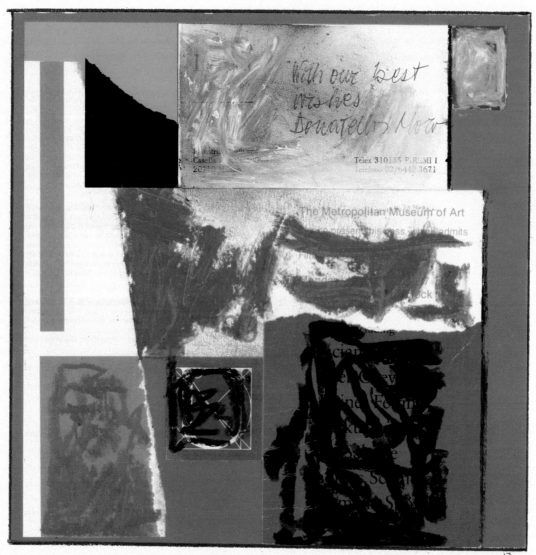

With our best
wishes
Donatello Moro

Telex 310135 PIRELMI 1
Telefono 02/6-442.3671

The Metropolitan Museum of Art

13
8
87

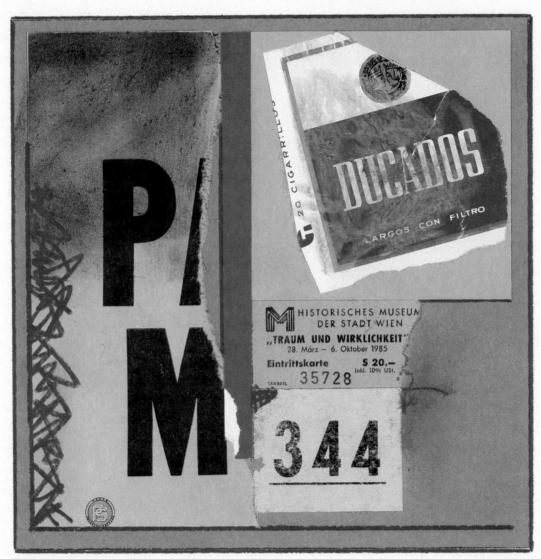

P/
M

DUCADOS
20 CIGARRILLOS
LARGOS CON FILTRO

HISTORISCHES MUSEUM
DER STADT WIEN
"TRAUM UND WIRKLICHKEIT"
28. März – 6. Oktober 1985
Eintrittskarte S 20.–
inkl. 10% USt.
35728

344

17
8
87

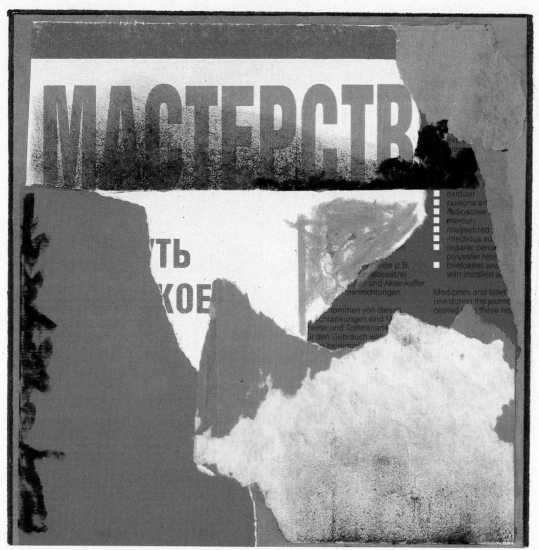

19
8
87

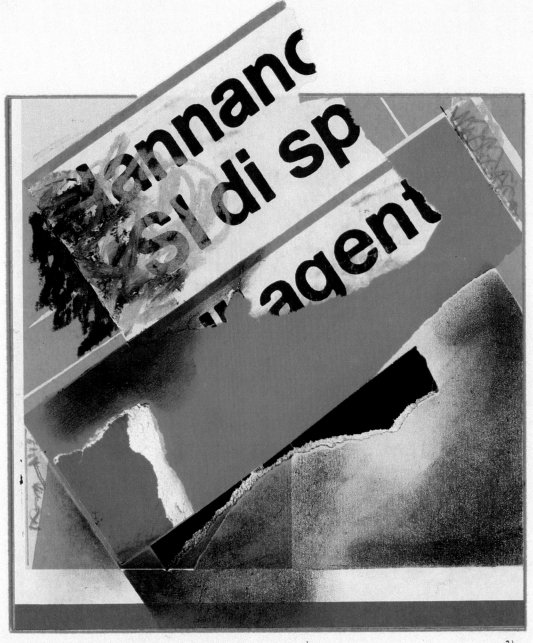

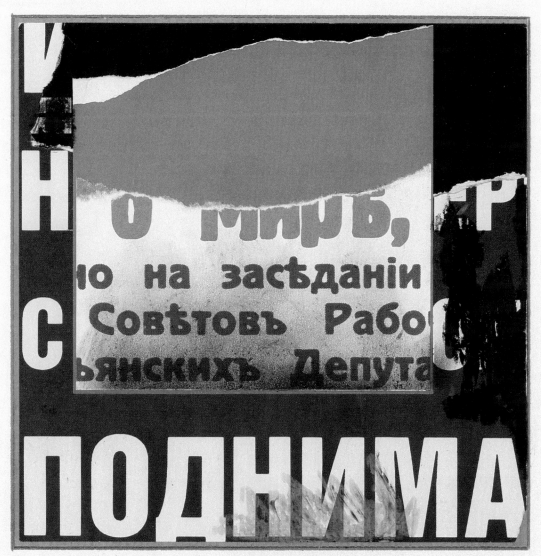

Michael Meier

22
B
87

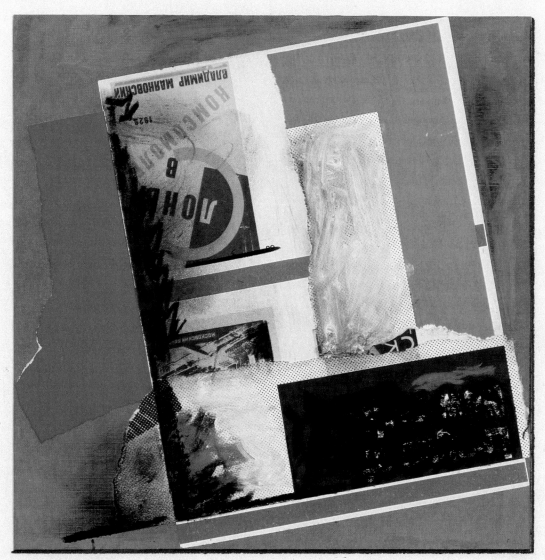

Michael Meier 24
 8
 87

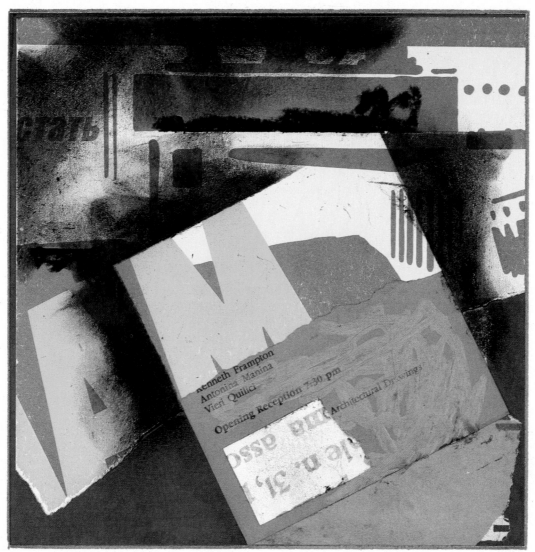

Kenneth Frampton
Antonina Manina
Vieri Quilici

Opening Reception 7:30 pm

Architectural Drawings

le n. 31, and asso

Michael Meier 25
 8
 87

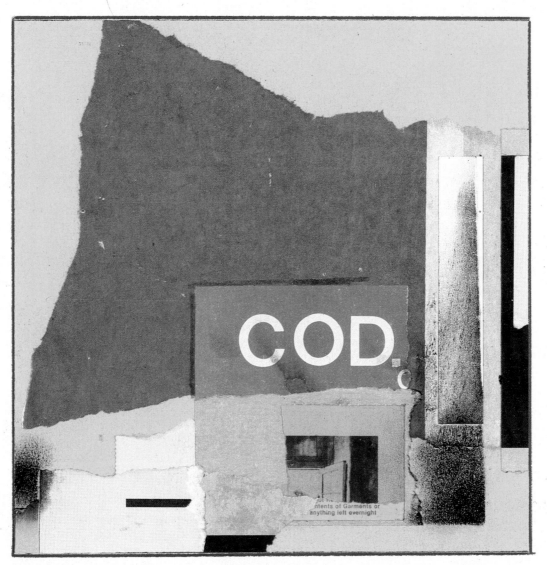

COD.

ntents of Garments or
anything left overnight

Michael Meier

4
9
87

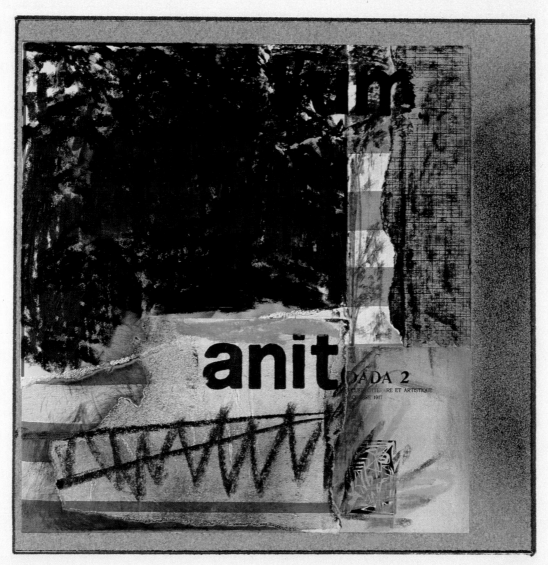

Michael Meier

10/9/87

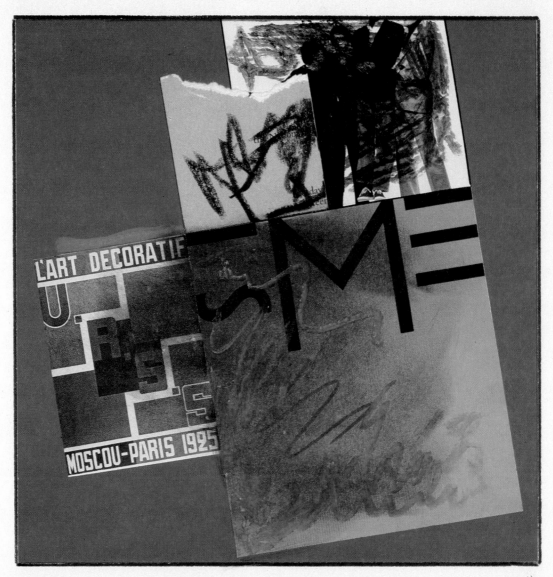

L'ART DECORATIF
U.R.S.S.
MOSCOU-PARIS 1925

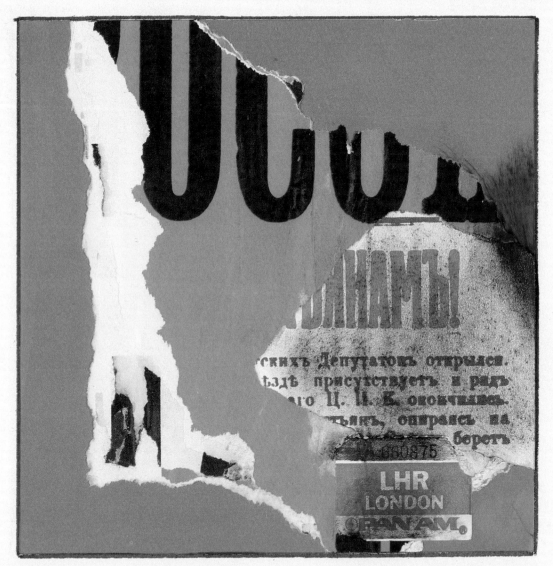

Michael Meier

12/9/87

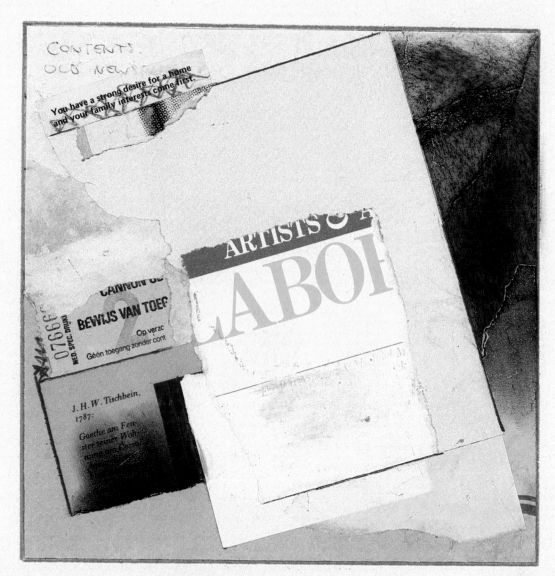

CONTENTS.
OLD NEWS

You have a strong desire for a home
and your family interests come first.

ARTISTS O
LABO

CANNON CI
BEWIJS VAN TOEG
07966
NED. SPEC. DRUKO
2
Op verzc
Gèèn toegang zonder cont

J. H. W. Tischbein,
1787:
Goethe am Fen
ster seiner Woh
nung am Corso

15
9
87

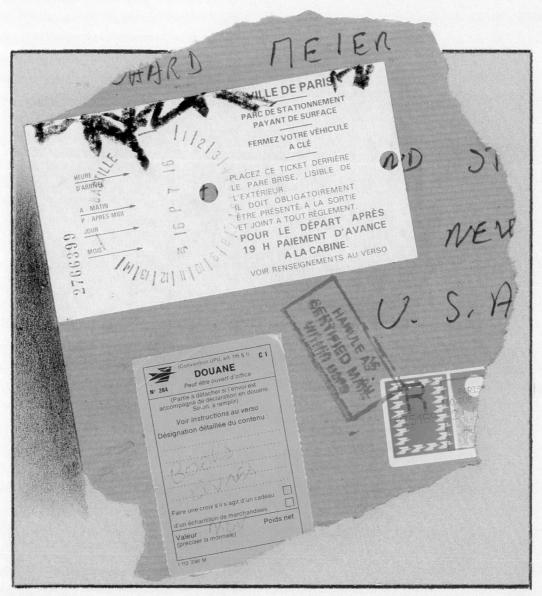

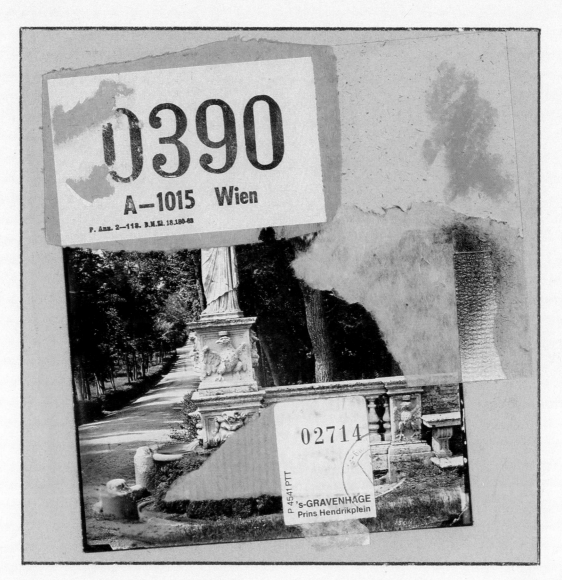

0390

A—1015 Wien

P. Ann. 2—118. B.M.K. 18.180-62

02714

P.4541 PTT

's-GRAVENHAGE
Prins Hendrikplein

21
9
87

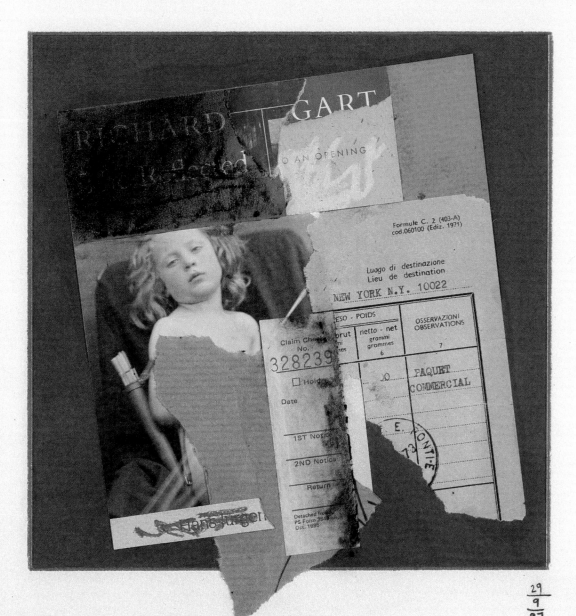

29
9
87

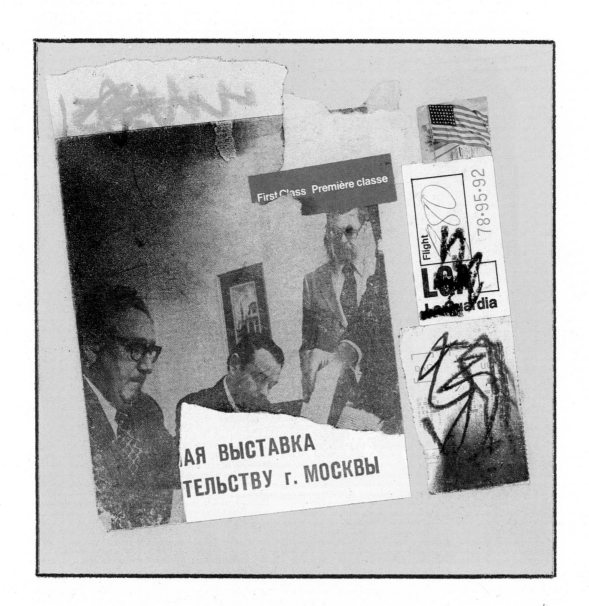

First Class Première classe

78·95·92

Flight

ЛАЯ ВЫСТАВКА
ТЕЛЬСТВУ г. МОСКВЫ

La strage di F
e contr MISED FOR
UESDAY
ocialist che
ter tic
d
I socialisti co
tativo del

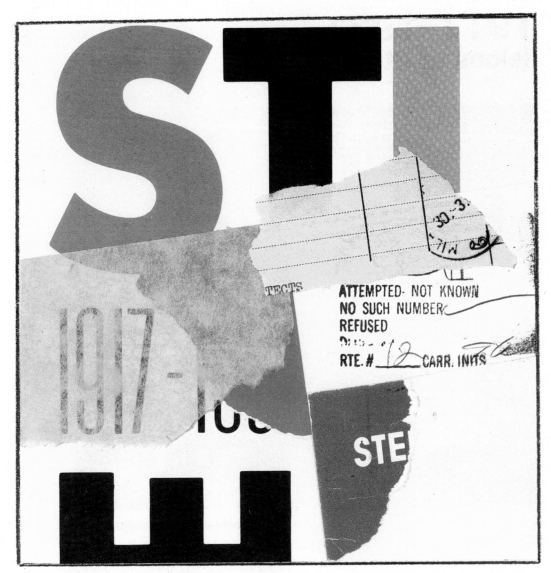

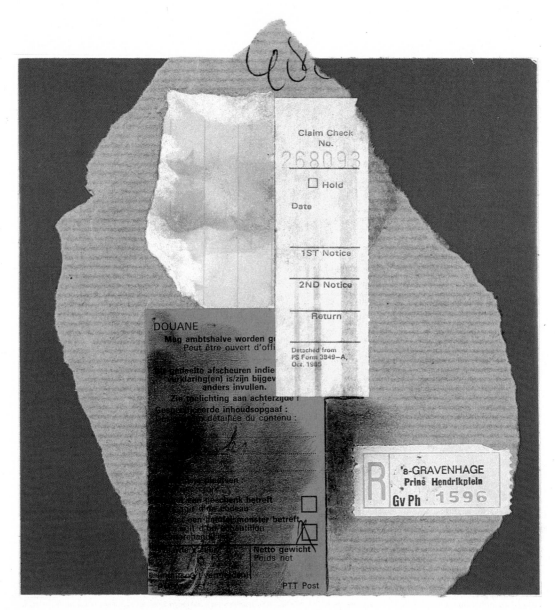

4
12
87

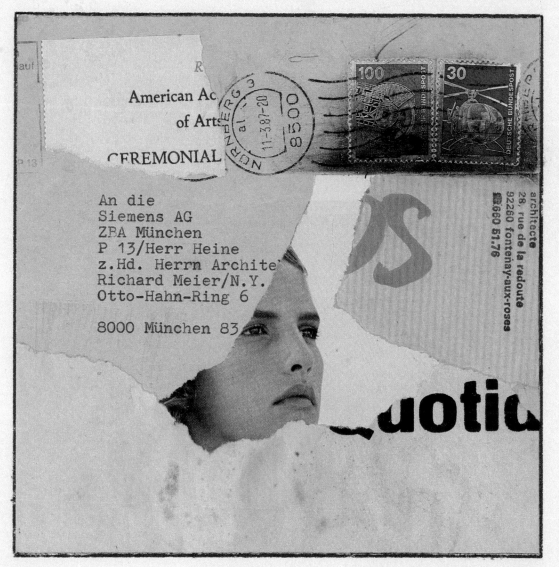

5
12
87